going
places

crossing bridges, turning corners, and going down a new path

By Mina Parker
Photographs by Daniel Talbott

Conari Press

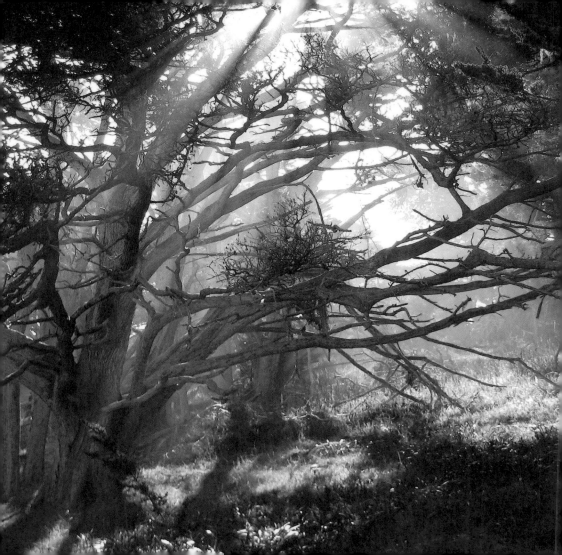

Setting Out

Life is a great adventure; the first steps taken in memory, the present passage being made this very moment, and the future, a map of possibilities. Whether you're taking a short trip or a long sojourn, it's all part of one journey, one long and winding path. To see with your own eyes, feel your way with your own hands. To make decisions and strike out in a singular direction. To reevaluate, to change course if necessary. To catch the updraft and dodge the undertow. To know the world through the prism of your heart, and to know your heart through its reflection in the expanse of all things. A wide open place to shout the secret of your wildest dreams, and hear your voice come echoing back, gathering layer and perspective.

"Oh, the places you'll go," the great Dr. Seuss reminds us. Here's to a little inspiration to encourage the first step, a companion in the final mile, and a reminder that the journey really is the destination.

Crossing a Bridge

Make voyages! Attempt them ... there's nothing else.

—Tennessee Williams

On your way! Go! Vamoose! What are you waiting for? No, really. What are you waiting for? The bridge is there, waiting to be crossed. Greener pastures may grow on the other side, or browner, but you won't know until you get there and see for yourself. You can stay and prepare, or you can set out today. Pack your ambition, your curiosity, and your openness, and embark on the adventure of a lifetime.

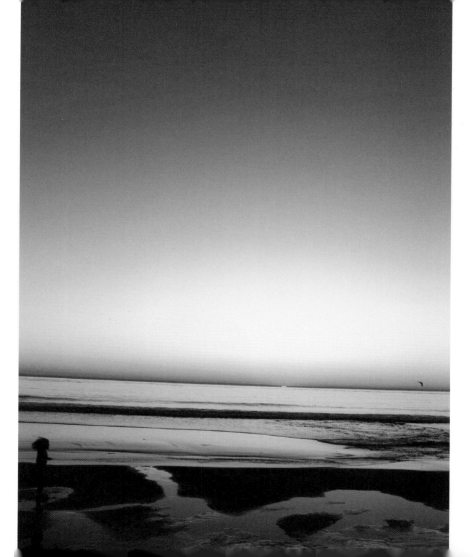

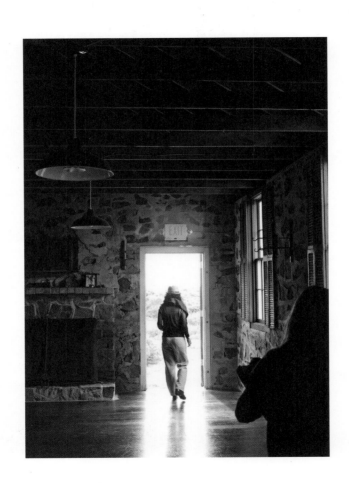

May angels gather at your shoulder.

—*Mary Anne Radmacher*

Blessings for any trip. Guides come forward
when needed, help arrives just in time,
and unseen hands send you on your way.

I travel not to go anywhere, but to go.
I travel for travel's sake. The great affair
is to move.

—*Robert Louis Stevenson*

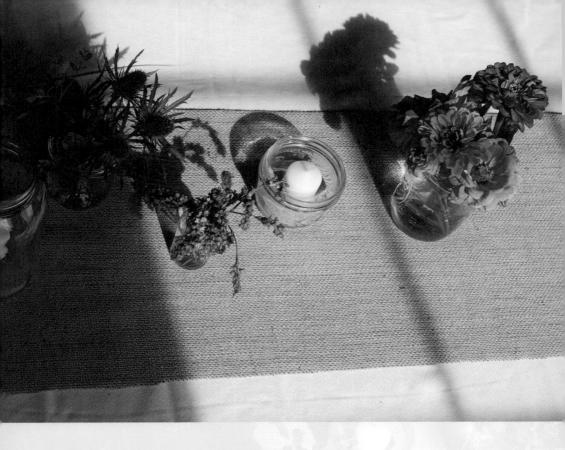

Make it new.

—*Ezra Pound*

Make it fly, let it soar.

Make it work, keep it real.

Make it shine, make it last.

Make it fun, pass it on.

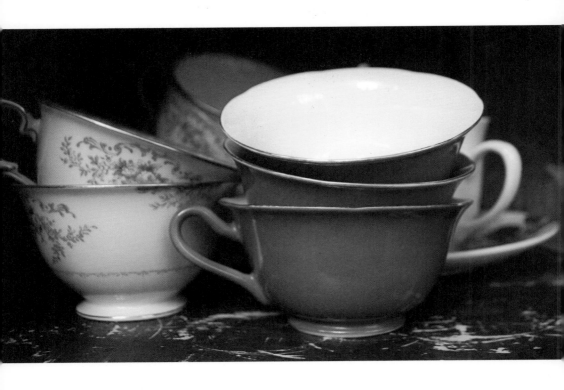

Travel light: Lay out what you think you need. Take half.
Leave plenty of empty space for new experience.

Thirty spokes share the wheel's hub;

It is the center hole that makes it useful.

Shape clay into a vessel;

It is the space within that makes it useful.

Cut doors and windows for a room;

It is the holes which make it useful.

Therefore benefit comes from what is there;

Usefulness from what is not there.

—Tao Te Ching *by Lao Tsu*
(translated by Gia-Fu Feng and Jane English)

We are all faced with a series of
great opportunities brilliantly disguised
as impossible situations.

—*Charles R. Swindoll*

A turtle travels only when it sticks its neck out.

—*Korean proverb*

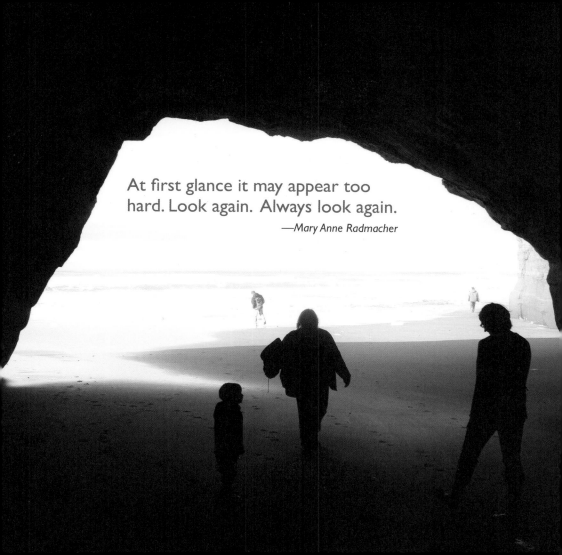

At first glance it may appear too hard. Look again. Always look again.

—Mary Anne Radmacher

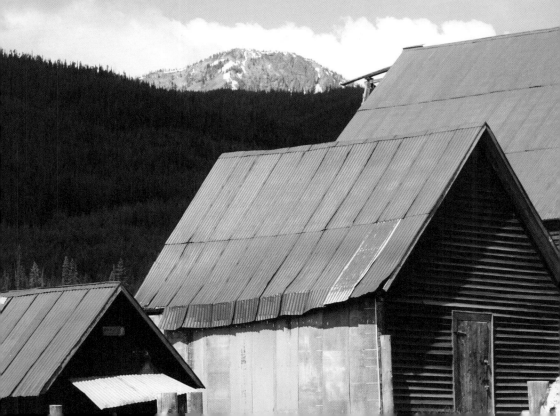

I have not failed. I've just found 10,000 ways
that don't work.

—*Thomas Alva Edison*

Every strike brings me closer to the
next home run.

—*Babe Ruth*

If there is a rule for success, this is it:
Reach higher, get stronger. Fail and learn
and try again.

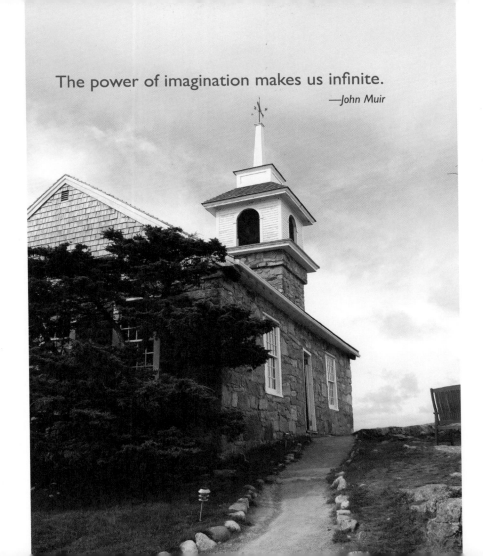

The power of imagination makes us infinite.

—*John Muir*

The magic is inside you. There ain't no crystal ball.

—*Dolly Parton*

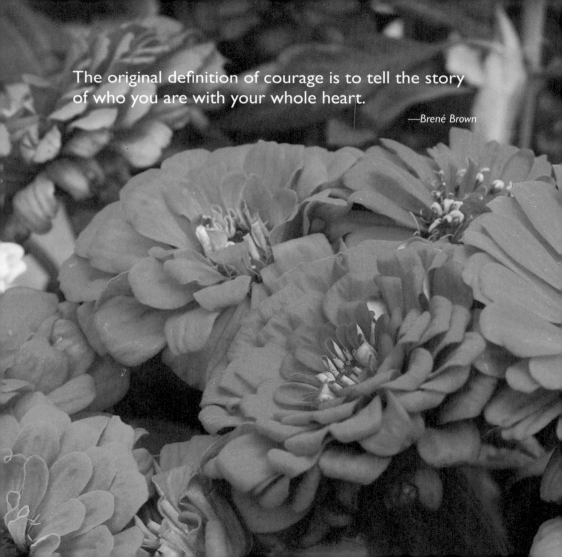

The original definition of courage is to tell the story of who you are with your whole heart.

—Brené Brown

Men go abroad to wonder at the height of mountains, at the huge waves of the sea, at the long courses of the rivers, at the vast compass of the ocean, at the circular motion of the stars, and they pass by themselves without wondering.

—*Saint Augustine*

Now crossing the bridge into inner space, bring a guidebook of the soul.

This map is not to scale. Wonder expands into every open space.

Live water heals memories. Look up the
creek and here it comes, the future . . .
 —*Annie Dillard*

Take me to the water.

Lapping in the rhythm that marked the
beginning of all moments.

Memory and motion.

Layers of love and loss and longing.

Take it to the water.

I will prepare and some day my chance will come.

We do not act because we know. We know because we are called upon to act.

Preparation is key. A wealth of information, consideration of the facts at hand. Strategy and practice. Pack your bag of tools and stand at the ready to chase down any challenge, overtake any opportunity.

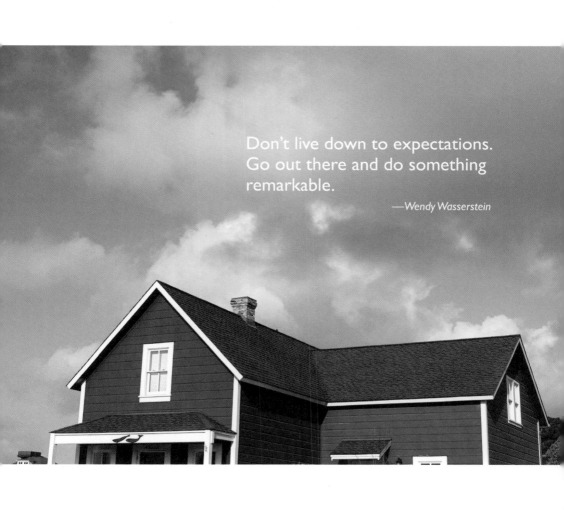

Don't live down to expectations.
Go out there and do something
remarkable.

—*Wendy Wasserstein*

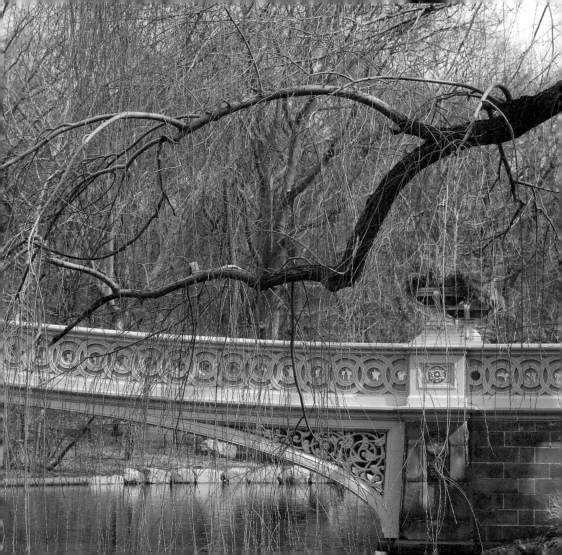

For my part I know nothing with any certainty, but the sight of the stars makes me dream.

—*Vincent van Gogh*

How long this bridge, how fast the current rushing below

How strong the gusts ahead, how forceful the helping winds from behind.

How far this path leads, or where it will end.

Unknown all, and yet I am guided by dreams.

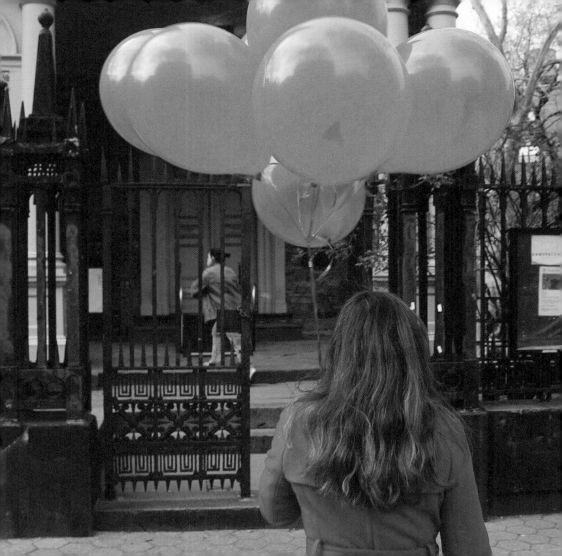

Turning a Corner

Midway on our life's journey, I found myself
In dark woods, the right road lost.

—Dante's Inferno

Welcome, change. Goodbye, status quo. Here is where our paths
diverge. The moment of awakening to a new journey, undertaken
at dawn. Doubts, fears, dark clouds. Take it on. Come prepared.
Come to win. Old rules were made for the way things were,
and those plans suited yesterday's circumstances. This calls for
something new. It's time to see what lies around the bend.

To change your life:
Start immediately,
do it flamboyantly, no exceptions.

—*William James*

The thing that's important to know is that
you never know.
You're always sort of feeling your way.

—*Diane Arbus*

If we begin with certainties, we shall end in doubts;
but if we begin with doubts, and are patient in them,
we shall end in certainties.

—*Francis Bacon*

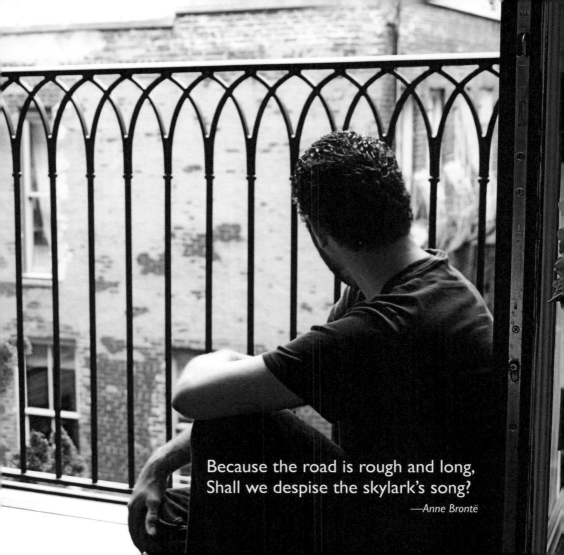

Because the road is rough and long,
Shall we despise the skylark's song?
—Anne Brontë

The voyage of the best ship is a zigzag line
of a hundred tacks.

—*Ralph Waldo Emerson*

Enjoy a meander.

Discover a reversal.

Upend a plan of attack.

With determination and a strong wind,
all will be progress.

May your eyes see anew.
May you notice, notice, notice.
May your legs be strong and your heart open.

If the sight of the blue skies fills you with joy,
if a blade of grass springing up in the fields
has power to move you, if the simple things
in nature have a message you understand,
Rejoice, for your soul is alive.

—*Eleanora Duse*

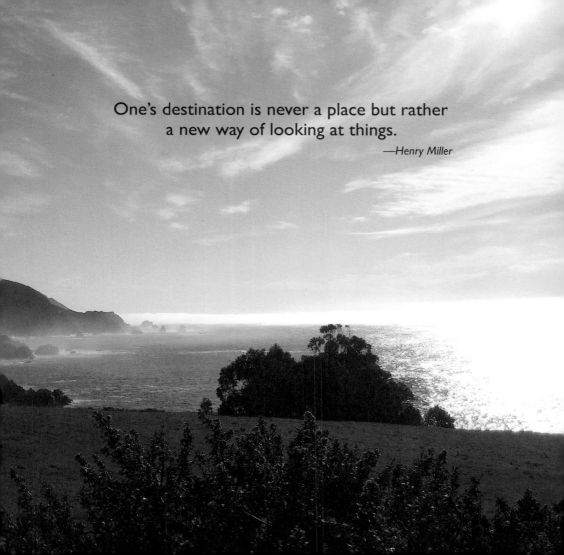

One's destination is never a place but rather a new way of looking at things.

—*Henry Miller*

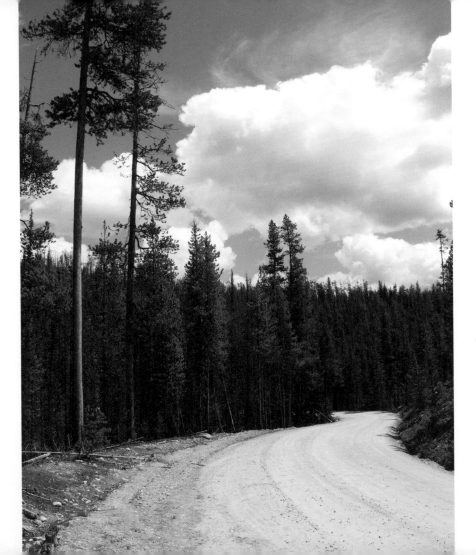

Travelers, there is no path, paths are made by walking.

—Antonio Machado

May the road rise up to meet you,
may the wind always be at your back.

—Irish toast

Travel is fatal to prejudice, bigotry, and narrow-mindedness.

—*Mark Twain*

Open doors are where you see them;
open minds follow.

The most powerful agent of growth and transformation is something much more basic than any technique: a change of heart.

—*John Welwood*

If I hold back, I'm no good. I'm no good. I'd rather be good sometimes than holding back all the time.

—*Janis Joplin*

Burst Open!

Come forward. Ready to succeed, willing
to fail. What other way is there?

Every time I look at my pocketbook,
I see Jackie Robinson.

—*Willie Mays*

We all tread a path laid down by the wise and the
courageous who came before us. Their strength inspires us
to follow in their footsteps; their legacy challenges us
to push farther toward our goals.

Have no fear of perfection—you'll never reach it.

—Salvador Dalí

Perfection. Let that one go.
Huge relief.

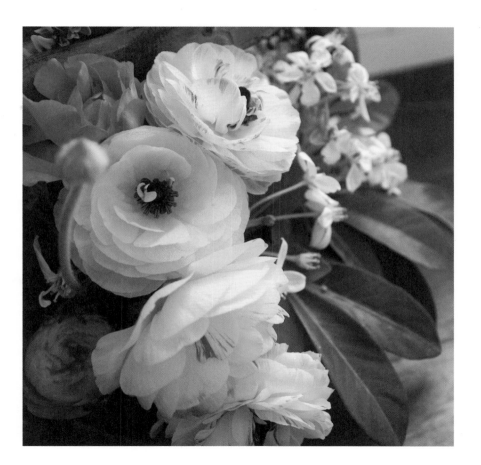

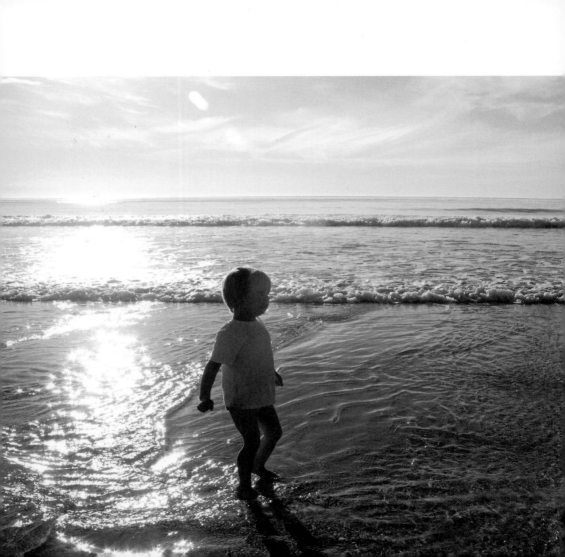

You have brains in your head
You have feet in your shoes
You can steer yourself
any direction you choose.

—*Dr. Seuss*

Take the third left. Cross the footbridge.
Detour to the lookout point.
Stop for a bite. Smell the roses.
Decisions, decisions.

**The soul of a journey is liberty, perfect liberty,
to think, feel, do, just as one pleases.**
—*William Hazlitt*

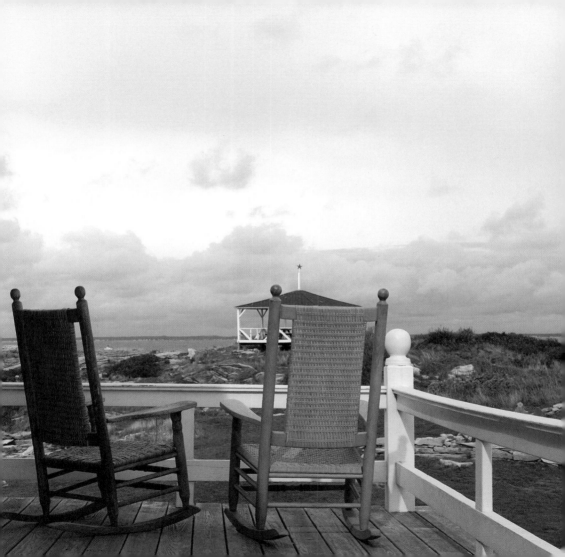

Sometimes I go about with pity for myself and all the while Great Winds are carrying me across the sky.

—*Ojibway saying*

May bright blessings lift your spirit.

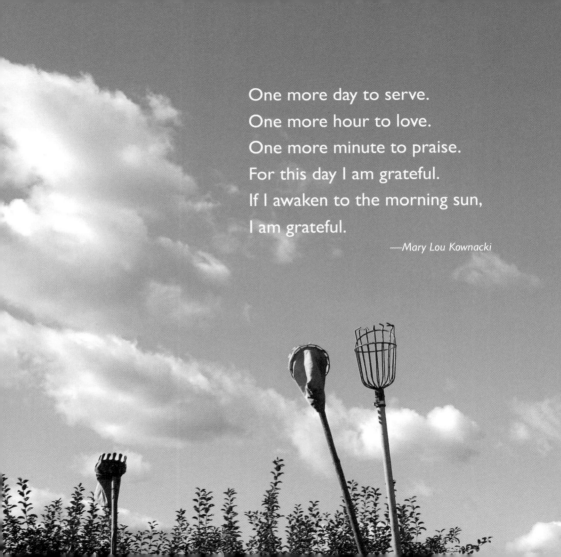

One more day to serve.
One more hour to love.
One more minute to praise.
For this day I am grateful.
If I awaken to the morning sun,
I am grateful.

—*Mary Lou Kownacki*

Boundless. Inexhaustible. No holds barred.
Constant. Free.

My motto: sans limites.

—*Isadora Duncan*

Finding a New Path

Pursue some path, however narrow and crooked,
in which you can walk with love and reverence.

—Henry David Thoreau

Your path. Finding it, making it; following, or leading. In groups,
or solitary. Driven to charge ahead, or allowed to linger and
explore. History builds behind and around you as you travel.
Friendships deepen, and root systems offer support as you
climb. You come unmoored from your fears, embrace the great
unknown as your greatest ally. Your destination bursts into view.
You come home whole.

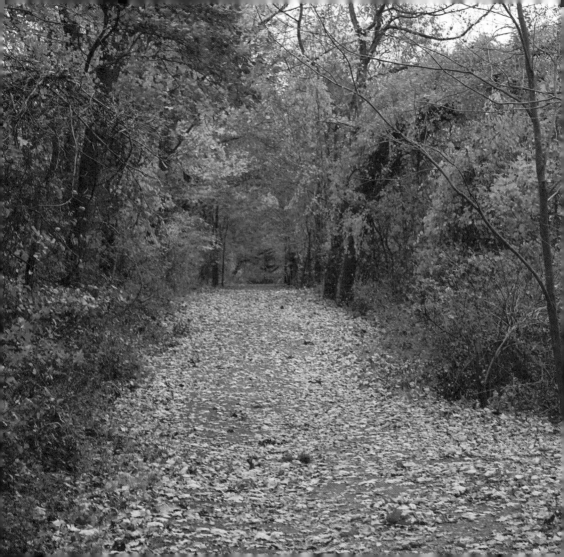

When one door closes, another opens; but we often look so long and so regretfully upon the closed door that we do not see the one which has opened for us.

—*Alexander Graham Bell*

May doors of wisdom open into rooms of opportunity.

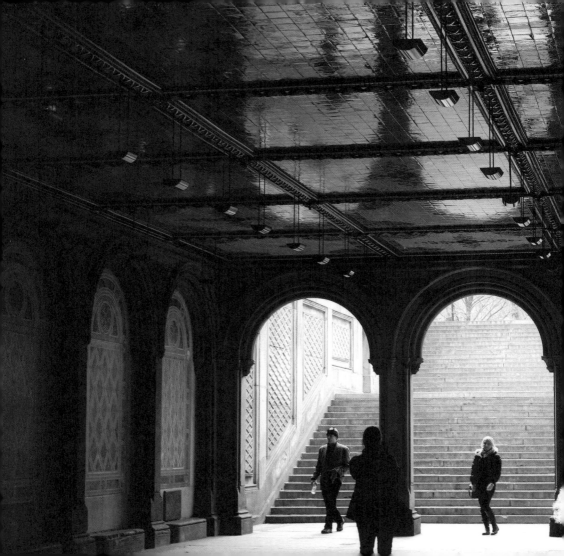

All journeys have secret destinations of which
the traveler is unaware.

—*Martin Buber*

Catacombs and altars. The graves of your ancestors.
Memory and meaning.

Or, the love of your life. A child you've hoped for. A new
beginning or direction.

Go laden and packed with questions, and return with the
prize of an unknown quest.

Let the beauty we love be what we do.
There are a hundred ways to kneel
and kiss the ground.

—*Rumi*

Do what you love; love what you do. Why not?

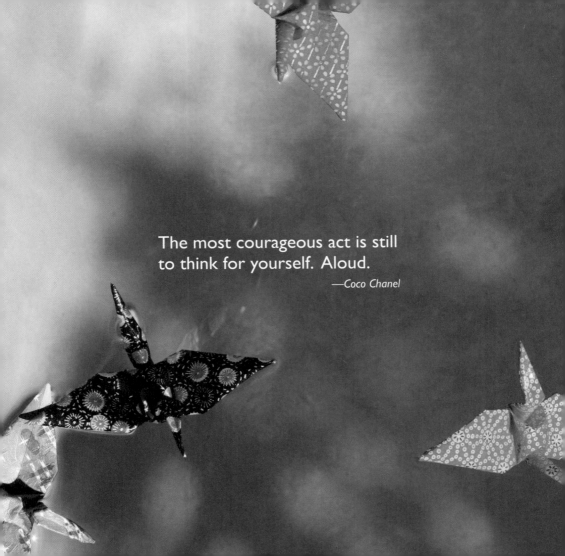

The most courageous act is still to think for yourself. Aloud.

—*Coco Chanel*

Raise your voice. Speak up. Be heard.

The world is a book and those who do not travel read only one page.

—*Saint Augustine*

Man cannot discover new oceans unless he has the courage to lose sight of the shore.

—*Andre Gide*

Even when there is a set course, the unknown beckons. An explorer's dreams guide the ship. With every choice you make, a new horizon. With every goal surpassed, a new reward.

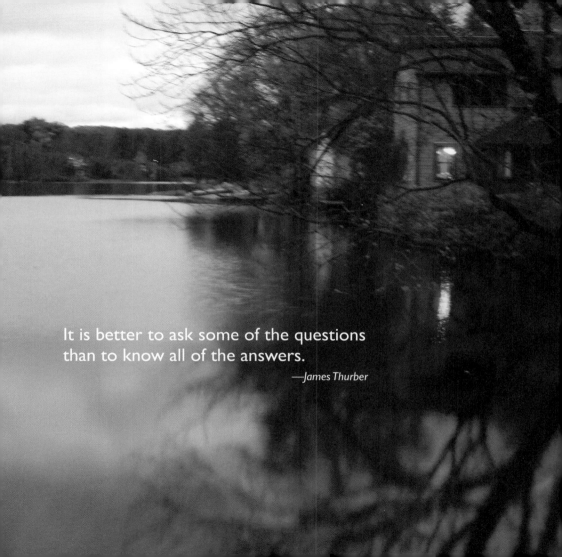

It is better to ask some of the questions
than to know all of the answers.

—*James Thurber*

May your path be strewn with flowers,
memories, friends and happy hours.
May blessings come from heaven above,
to fill your life with peace and love.

—English blessing

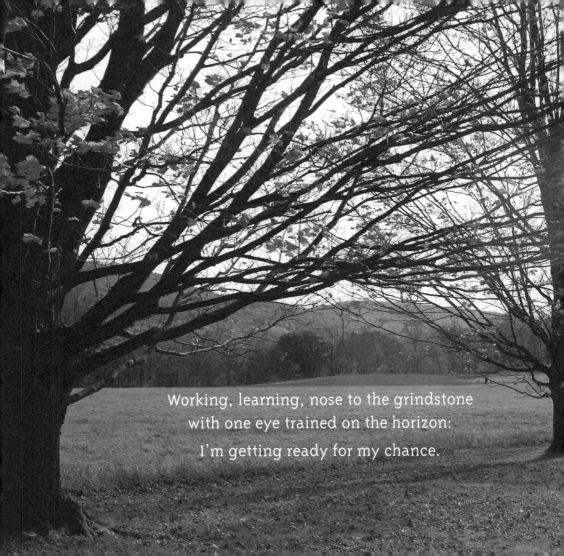

Working, learning, nose to the grindstone
with one eye trained on the horizon:

I'm getting ready for my chance.

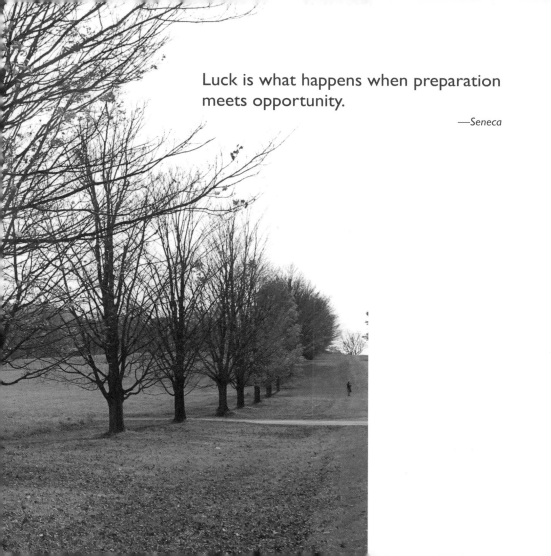

Luck is what happens when preparation meets opportunity.

—*Seneca*

Over every mountain there is a
path, although it may not be seen
from the valley.

—*Theodore Roethke*

May your courage lead you out of the comfortable valley
and up, up, up over daunting peaks.

Diligence is a good thing, but taking things easy is much more restful.

—*Mark Twain*

Take it easy. Take care. Rest and renew.

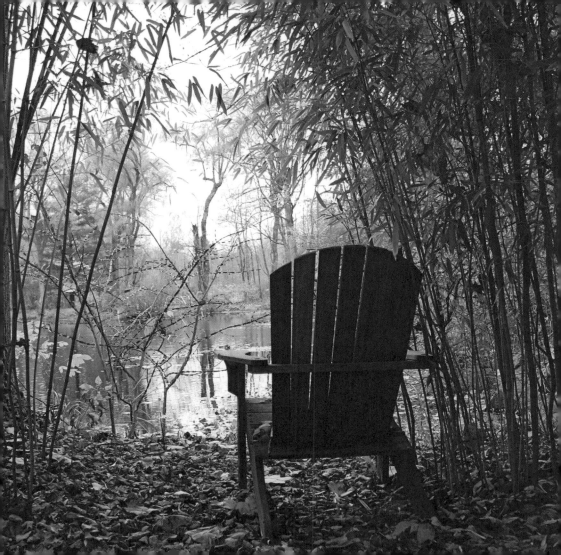

May your path be swept of danger.

—*African prayer*

I will sweep it for you, my friend,
and you may sweep it for the next
kind soul, if you choose.

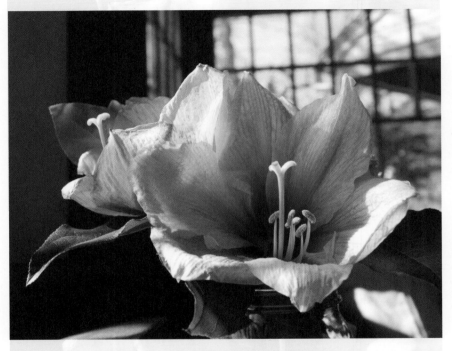

Never go on trips with anyone you do not love.

—*Ernest Hemingway*

The moon and sun are eternal travelers. Even the years wander on. A lifetime adrift in a boat, or in old age leading a tired horse into the years, every day is a journey, and the journey itself is home.

—*Matsuo Bashō (translated by Sam Hamill)*

May you share the path with a true friend.

Not all those who wander are lost.

—*J. R. R. Tolkien*

May your road be long and winding.

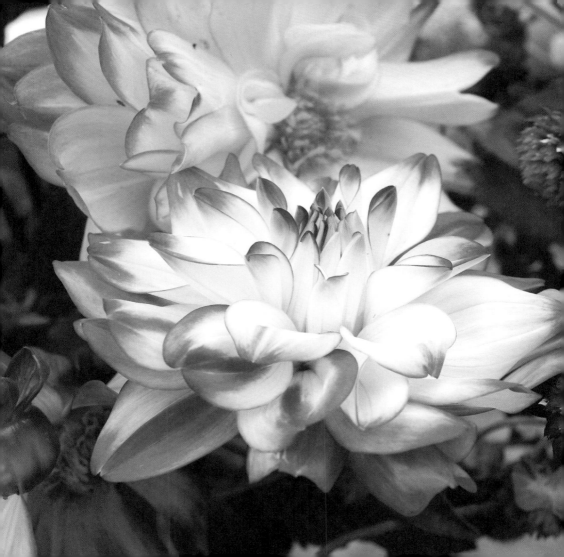

Our lives are not constructed of well-laid plans or controlled events or any other predictable thing which may be brewed in the cauldron of our hopes. Our lives are simply a succession of nows. Knowing this, extend your hand with the strongest reach and offer the best you are able.

—Mary Anne Radmacher

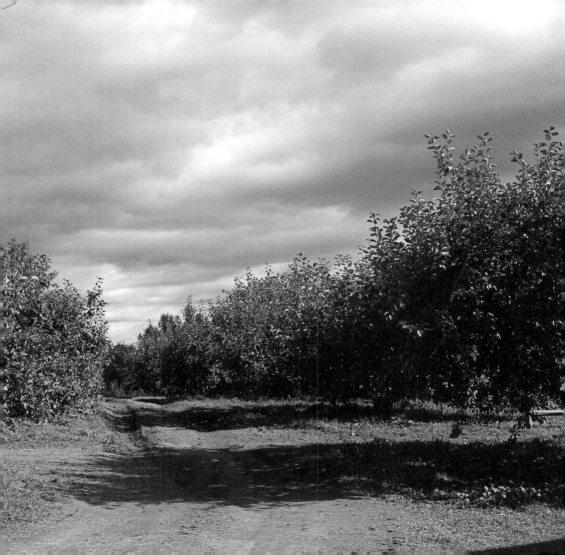

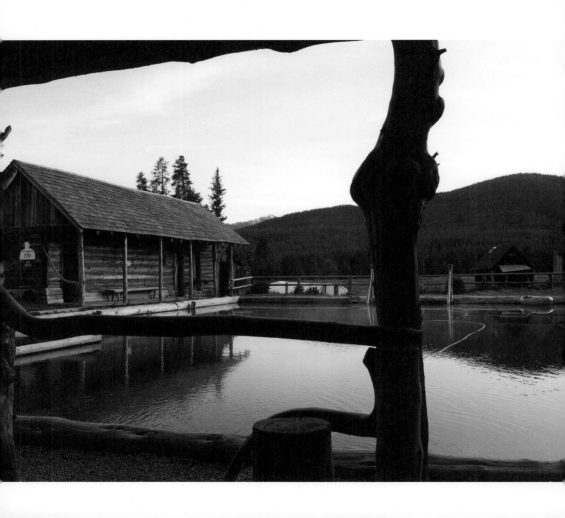

And will you succeed?
Yes! You will, indeed!
(98 and 3/4 percent guaranteed.)
KID, YOU'LL MOVE MOUNTAINS!

—*Dr. Seuss*

As we let our own light shine, we unconsciously give other people permission to do the same.

—Nelson Mandela

May your path be illuminated.

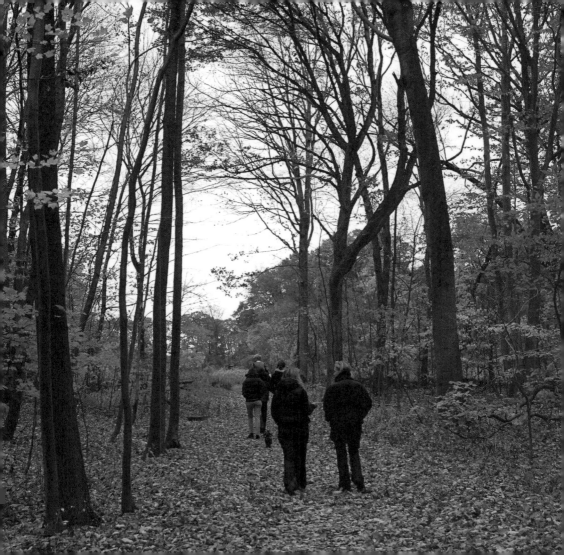

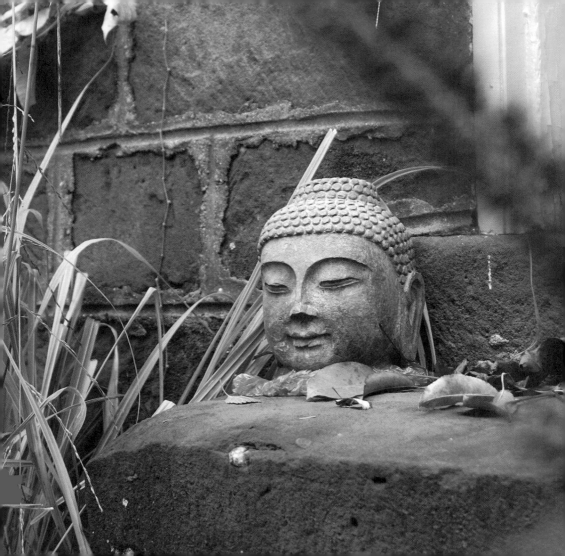

Your feet will bring you to where your heart is.

—*Irish proverb*

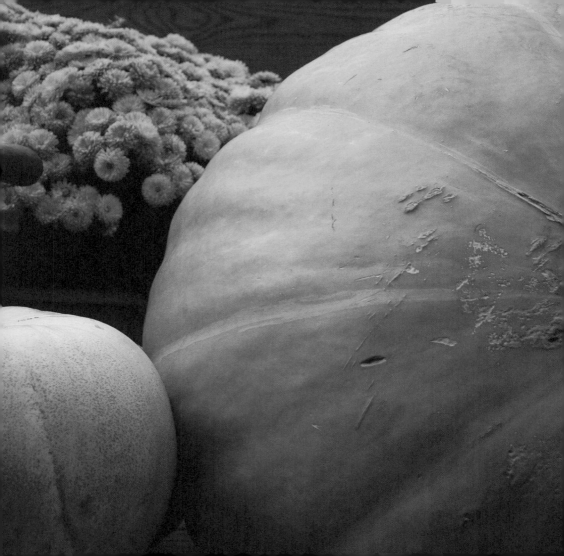

First published in 2011 by Conari Press, an imprint of

Red Wheel/Weiser, LLC

665 Third Street, Suite 400

San Francisco, CA 94107

www.redwheelweiser.com

ISBN: 978-1-57324-518-0

Library of Congress Cataloging-in-Publication Data available upon request

Cover design by Nancy Condon

Cover photograph © Daniel Talbott

Interior design by Nancy Condon

Printed in Hong Kong
GW

10 9 8 7 6 5 4 3 2 1

Dedicated to Robert Rosen.